FROM THE FILMS OF

Harry Potter

The Divination
Crystal Ball

T0364029

RP Minis®
Hachette Book Group
1290 Avenue of the Americas, New York, NY 10104
www.runningpress.com
@Running_Press

First Edition: September 2021

Published by RP Minis, an imprint of Perseus Books, LLC, a subsidiary of Hachette Book Group, Inc. The RP Minis name and logo is a registered trademark of the Hachette Book Group.

The Hachette Speakers Bureau provides a wide range of authors for speaking events. To find out more, go to www.hachettespeakersbureau.com or call (866) 376-6591.

The publisher is not responsible for websites (or their content) that are not owned by the publisher.

ISBN: 978-0-7624-7490-5

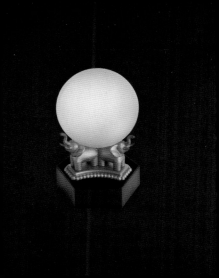

"Explore the noble art of Divination."

—Professor Sybill Trelawney,
*Harry Potter and the
Prisoner of Azkaban*

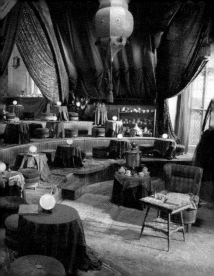

The Divination Crystal Ball

<hr/>

In *Harry Potter and the Prisoner of Azkaban,* students at Hogwarts School of Witchcraft and Wizardry gaze into crystal balls during Divination class. The swirling fog within these glass orbs can reveal future events, but only if the users have the gift of Sight.

"Here in this room,
you will discover if you
possess the Sight!"

—Professor Sybill Trelawney,
*Harry Potter and the
Prisoner of Azkaban*

During their first Divination class, in *Harry Potter and the Prisoner of Azkaban*, Harry, Hermione, and Ron meet Professor Sybill Trelawney. Professor Trelawney introduces herself, telling the skeptical students, "Together we shall cast ourselves into the future!"

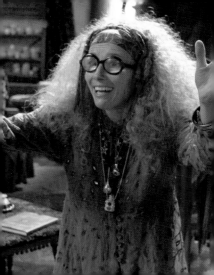

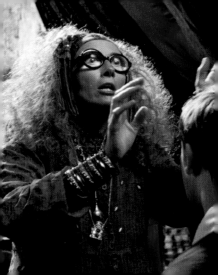

When asked to describe her character, Professor Trelawney, in one sentence, actress Emma Thompson responded, "Mad as a bucket of snakes."

"The truth lies buried
like a sentence deep
within a book, waiting
to be read."

—Professor Sybill Trelawney,
*Harry Potter and the
Prisoner of Azkaban*

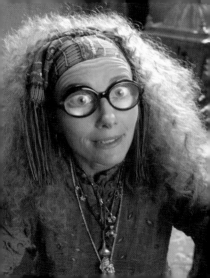

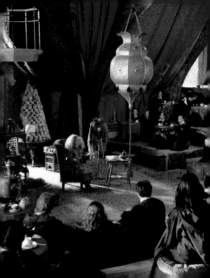

During her first Divination class in *Harry Potter and the Prisoner of Azkaban*, Professor Trelawney introduces students to Tessomancy, which she describes as "the art of reading tea leaves."

"Are you in the beyond?
I think you are!"

—Professor Sybill Trelawney,
*Harry Potter and the
Prisoner of Azkaban*

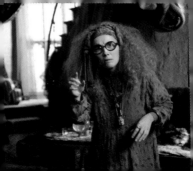

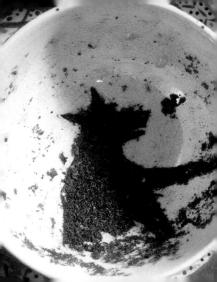

In Divination class, when Professor Trelawney reads the leaves in Harry's teacup, she sees the Grim. She describes this omen as one of darkest in the Wizarding World— an omen of death.

In *Harry Potter and the Prisoner of Azkaban*, Hermione often criticizes the art of Divination, calling the discipline a "load of rubbish."

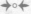

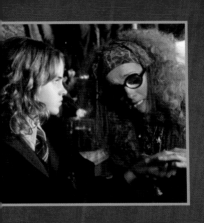

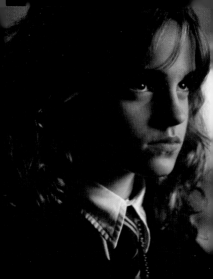

"If you ask me, Divination is a very woolly discipline."

—Hermione Granger,
*Harry Potter and the
Prisoner of Azkaban*

Actress Emma Thompson noted the difficulty of wearing Professor Trelawney's distinctive eyewear, which were, in fact, magnifying glasses to make her eyes look bigger. However, Thompson understood the importance of this character-building accessory, stating, "[Professor Trelawney] sees into the future all the time. So, my notion being that if she can see into the future all the time, she can't see anything at all in the present."

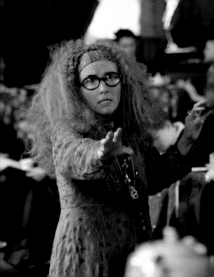

"Broaden your minds.
You must look beyond!"

—Professor Sybill Trelawney,
*Harry Potter and the
Prisoner of Azkaban*

In *Harry Potter and the Prisoner of Azkaban,* during her second Divination class, Professor Trelawney introduces her students to crystal balls. She teaches Harry, Hermione, Ron, and the other students that, "The art of crystal-gazing is in the clearing of the inner eye. Only then can you see."

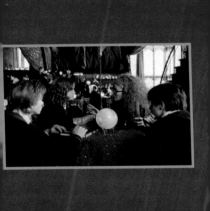

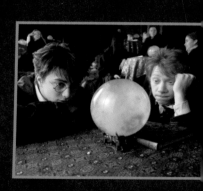

During their second Divination class, Harry and Ron attempt the art of crystal-gazing but do not see anything within the orb.

Hermione attempts gazing into the future as well. However, Professor Trelawney tells Hermione that she does not "possess the proper spirit for the noble art of Divination."

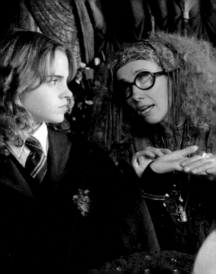

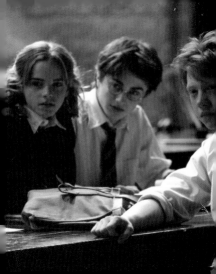

Emma Thompson admired her young castmates, stating, "They're very nice, all the kids are fantastic, fantastic to play for. They're very available and open and they're wonderful, wonderful people."

After Divination class, Harry
returns alone to Professor
Trelawney's classroom. Gazing
into a crystal ball, the he sees
the face of Sirius Black, who
whispers Harry's name.

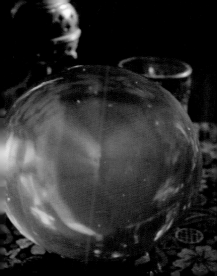

Professor Trelawney interrupts Harry's crystal-gazing to deliver a prophecy: "Tonight, he who betrayed his friends, whose heart rots with murder shall break free. Innocent blood shall be spilt, and servant and master shall be reunited once more."

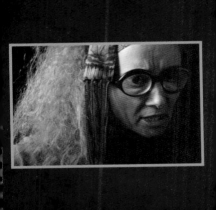

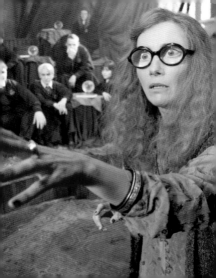

In *Harry Potter and the Order of the Phoenix*, Dolores Umbridge visits Divination class to assess Professor Trelawney, asking the professor to perform a prophecy on command. After a moment, Professor Trelawney hesitantly replies, "You are in grave danger!"

In *Harry Potter and the Order of the Phoenix*, the look of the Divination classroom changed from earlier films. In an interview, the film's set dresser, Stephanie McMillan, explained the updates: "The walls are still covered in drapery, lots of curtains, but just all the colors are much more somber.... It's much, much more down-market, and looks more interesting, I think, and ... conveys [Professor Trelawney's] character much better ... she's a broken woman.

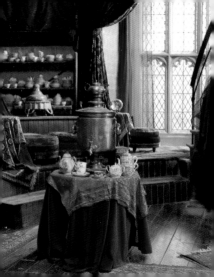

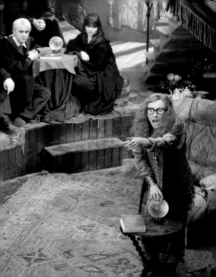

After her assessment, Dolores Umbridge cancels Divination class and attempts to have Professor Trelawney removed from Hogwarts. However, Professor Albus Dumbledore objects, proclaiming that Umbridge does not have the authority to banish teachers from the grounds. Professor Trelawney stays and eventually helps defend the school during the Battle of Hogwarts in *Harry Potter and the Deathly Hallows—Part 2*.

"Hogwarts is my home."

—Professor Sybill Trelawney,
*Harry Potter and the
Order of the Phoenix*

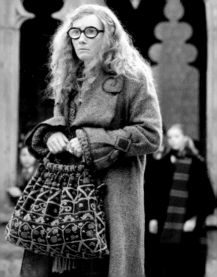

This book has been bound using
handcraft methods and Smyth-sewn
to ensure durability.

Designed by Jenna McBride.

Written by Donald Lemke.